IMAGES
of Rail

THE INCLINES OF CINCINNATI

This sketch shows the Bellevue House and the Elm Street Incline, as seen from Freeman Avenue. Caroline Williams, the artist, lived here during the era of the inclines. Williams, a Cincinnati native, had a gift for capturing the essence of a scene.

On the cover: The Mount Adams Incline is seen here around 1910. (Photograph by Earl Clark.)

IMAGES
of Rail

THE INCLINES OF CINCINNATI

Melissa Kramer

ARCADIA
PUBLISHING

Copyright © 2009 by Melissa Kramer
ISBN 978-0-7385-6130-1

Published by Arcadia Publishing
Charleston SC, Chicago IL, Portsmouth NH, San Francisco CA

Printed in the United States of America

Library of Congress Catalog Card Number: 2008929810

For all general information contact Arcadia Publishing at:
Telephone 843-853-2070
Fax 843-853-0044
E-mail sales@arcadiapublishing.com
For customer service and orders:
Toll-Free 1-888-313-2665

Visit us on the Internet at www.arcadiapublishing.com

For the Cincinnati Railbuffs, who keep history alive.

Contents

Acknowledgments — 6

Introduction — 7

1. Cincinnati Heads for the Hills — 9

2. Hilltop Fun — 69

3. The Men Who Kept the Rails — 89

4. Ups and Downs — 101

5. The End of an Era — 113

Acknowledgments

I would like to express my appreciation to the Cincinnati Railbuffs, who gather twice a month to discuss the history of rail, for welcoming me into their group. As true buffs, many of them are collectors of photographs, journals, and other memorabilia from the age when trains rather than automobiles were the preferred method of transportation. In particular, I thank Phil Lind, who provided the majority of photographs for this project. I cannot thank him enough for his generous accommodation to my requests for information and photographs. His considerable knowledge of the Cincinnati Street Railway and his passion for the history of Cincinnati made him a credible reference and an invaluable resource. I also want to thank Kevin Grace, Tom White, Earl Clark, Bill Van Doreen, Dan Finfrock, Fred Bauer, Bill Myers, Alvin Wulfekuhl, and Larry Fobiano. John H. White Jr., who wrote the beautiful and comprehensive coffee-table book about Cincinnati's inclines *Cincinnati: City of Seven Hills and Five Inclines*, contributed photographs and historic background and proofread this book for me.

I would like to thank my friend Jerry Seiter, another Cincinnati Railbuff, for introducing me to the group. Jon Miller, the librarian at the Cincinnati Historical Transit Association, has generously loaned materials and photographs from the files of the Mount Adams and Bellevue Inclines. Valda Moore and Richard Jones at the Price Hill Historic Society have been very generous with photographs and information. Melissa Basilone, my editor, has been a pleasure to work with. Elizabeth Meyer and Sarah Maguire at the University of Cincinnati DAAP Library offered their technical expertise. Elissa Sonnenberg, my mentor and academic advisor at the University of Cincinnati, has been a good source of guidance. Sometimes it has been difficult to get an accurate reconstruction of the age of the inclines, since accounts can contradict each other. John Brolley, my history professor, taught me how to search out credible sources.

My father Jerry's love of words and history was infectious. From an early age, he described for me the people and events connected with the bridges, buildings, and streets of Covington and Cincinnati. From him I learned that every structure has a story.

My daughter Dana offered help when I needed it the most, sorting newspaper articles and photographs. She brought her own enthusiasm to the project, and her passion for history encouraged me. My son Zachary contributed in his own way by allowing me to be "half a mom." He developed a preference for frozen pizza, which allowed me to spend more time on the book.

Most of all, to my husband Dale, thank you for always believing in me.

INTRODUCTION

July 25, 2008, marked the 60th anniversary of the day the last streetcar, No. 2446, was pulled up the Mount Adams Incline to the top of the hill. The ride took two and a half minutes and lasted 72 years. Four resorts, the Lookout House, the Highland House, the Bellevue House, and the Price Hill House, clung to the city's hillsides at the heights of four of the inclines, and riders seeking refreshment, relaxation, and fresh air had a respite from the tedium of factory work and the stench of the city.

The inclines, half railroad and half elevator, tamed the disobedient terrain of Cincinnati during a time when the smoky air was difficult to breathe. Tuberculosis was rampant, and the stench from the Erie Canal had become unbearable. Houses were clustered together. Chimneys and smokestacks from the furniture, meatpacking, and beer industries funneled clouds of black soot into the sky. Through the dark smog, city dwellers looked to the bare hilltops for relief. Beginning around 1850, omnibuses were used. It was not, however, an optimal solution. The trek was burdensome for the horses and for the driver, who often had to jump out and block the wheels so the horses could stop and rest. These journeys were less than pleasant for the passengers as well, as the muddy roads were filled with deep ruts, and the carriage lurched along behind the tired horses.

The city was trapped against the surrounding hills, and an immediate solution was necessary. Joseph Stacy Hill, a local soap maker, traveled to Pittsburgh and realized that Cincinnati's uncooperative topography, similar to Pittsburgh's, could be conquered in the same way. Hill and his associate, George Smith, obtained a state charter, and on May 12, 1872, Cincinnati's first inclined plane, the Main Street, or Mount Auburn Incline, began carrying passengers up Mount Auburn.

The business partners, fearing poor returns on their investment, decided that an attraction at the top would draw riders. The Lookout House, an entertainment complex, was built, and crowds of up to 10,000 regularly flocked to the hilltop by way of the Mount Auburn Incline. The proprietor never failed to draw people up the incline to his establishment. He even had a giant whale brought to the Lookout House in a specially made saltwater tank. Hot air balloons and fireworks entertained the guests as they sipped cold beer and savored the fresh air and the view from their new vantage point. However, a fatal accident in 1898 soon brought business at the Lookout House and the incline to a screeching halt.

The Mount Adams Incline, built in 1876, operated until 1948. It was the last incline to close. The idea of a hilltop resort was taken to a new level, and the thrill of riding the Mount Adams

Incline was heightened when it was followed by a visit to the Highland House. The July 1883 issue of *Harpers New Monthly* described a nighttime ride on the incline:

> From the street below, the hill looks as if capped by some fortification all ablaze with military industry . . . The platform receives the streetcar with its horses . . . and it slowly ascends the incline. The city seems to sink beneath it, then expand into a great black chart illustrated with interminable lines of lamps radiating away in uneven lines into the distance . . . and disappearing into the outer darkness or the abyss of the river.

The inclines had given birth to a new breed of entertainment that only Cincinnati could claim as its own. Sweeping views of the city from the famed Highland House, combined with legendary Cincinnati beer and world-class symphony orchestras, drew regular crowds of 8,000. So huge was the success that traveling salesmen at the dawn of the 20th century called Cincinnati "the Paris of America." The Queen City of the West had made its mark on the cultural map.

Five inclines stretched from the valley to the hilltops of Cincinnati at Elm Street or Bellevue, Fairview, and Price Hill. Both the Bellevue House and the Price Hill House had facilities similar to the Highland House, and Cincinnati's hills became an asset rather than a burden. Besides fresh air and entertainment, the inclines made development of the suburbs a reality. Thousands relied on them as an inexpensive, convenient way to travel to and from work every day. A ride on the incline was a cheap date and the number one tourist attraction until the end in 1947.

It begs the question—if the inclines and resorts were so popular, what happened to them? Oddly enough, the inclines hastened their own demise. In making the suburbs accessible, the inclines also created a demand for quick, cheap transportation to and from them. Eventually, the inclines were unable to compete with automobiles. Also, although they were extremely popular, they were not lucrative. Besides labor costs of a fairly large crew, the maintenance of the machinery, trestles, and tracks was expensive. The Cincinnati Street Railway Company that operated the Bellevue, Fairview, and Mount Adams inclines was a private corporation with stockholders who expected dividends. Pressure to simultaneously economize and modernize frustrated both the management and the owners. Buses were the way of the future, and automobiles were seen as more convenient. When inspections revealed defects, they were shut down. The owners, fearing financial ruin, saw the opportunity to abandon the venture.

Citizens who had developed a fondness for the inclines, particularly the Price Hill and Mount Adams, were devastated. Politicians under pressure from the city ordered the Cincinnati Street Railway Company to repair the Mount Adams Incline without offering a dime to help restore it. Because of the steep grade and narrow right-of-way, much of work had to be done without heavy equipment. The bill came to $150,000 for repairs plus $45,000 per year to maintain it. Another option was for the city to take over operation. However, progress not preservation was the order of the day. Mayor Albert D. Cash, in a statement in the October 7, 1949, *Cincinnati Enquirer*, said, "Everyone feels nostalgia for this and other 'old monuments,'" but he was "opposed to saddling the taxpayers with this much expense." A similar situation in San Francisco occurred when the mayor tried to eliminate the cable cars. Citizens voted more than three to one for them to stay, and today cable cars are synonymous with San Francisco. Pittsburgh continues to operate two of its inclines. The Duquesne Incline was saved by a group of citizens, and today it operates on society memberships, donations, and proceeds from the museum. Historic preservation groups were nonexistent, however, during the deadlock in Cincinnati. John H. White Jr., in his book *Cincinnati: City of Seven Hills and Five Inclines*, said, "If this debate had taken place a decade or two later, it is likely that the city would have accepted these as a good investment in terms of tourism and public pride." Letters to the editors of the city's newspapers were evidence of the public's desire to save the inclines, but there seemed to be no other recourse. In 1950, the property was sold. White laments the shameful situation when he says, "The incline was said to represent something priceless in the life of the city, something irreplaceable. Perhaps the best argument was that a community is only as big as its traditions; size and wealth mean nothing if a soul is lacking."

One
CINCINNATI HEADS FOR THE HILLS

Looking up at the lift of the Mount Adams Incline, this photograph was probably taken in the 1940s. (Courtesy of Phil Lind.)

The early Cincinnatians, determined to conquer the difficult terrain, simply built steps into the hillside when the ground became too steep to lay a road. The grid of the city disintegrates at the foot of the hills where steps between the buildings disappear into the dense foliage, cutting into the hillside under a canopy of trees and emerging once again at the summit. Following the path of least resistance, they twist and turn for no apparent reason. The climber leaves one world and, upon passing through an opening or turning a corner, enters another. Often balconies overlook the steep, serpentine streets, as in this view of the top of Sycamore Street in Mount Auburn. Homes that appeared to be two stories at street level were actually six or more stories when viewed from behind, with the ground floor opening onto an entirely different neighborhood. The whole effect was like that of a medieval kingdom. There are nearly 400 sets of hillside steps in Cincinnati, many of which are left over from the days before the inclines. This sketch is by Caroline Williams.

Thousands of people lined up to ride the city's first incline, which opened on May 12, 1872. This early photograph shows James M. Dougherty, supervisor of the plane, holding the gate while a conductor looks on from inside the streetcar. (Courtesy of Phil Lind.)

This late-1800s photograph shows passengers boarding a streetcar at Governor's Square at Fifth and Main Streets. The line, which carried passengers from Fountain Square to the Cincinnati Zoo via the Mount Auburn Incline, was electrified in 1889. Governor's Square continues to be an important hub for Cincinnati's public transportation system.

William Nagel, motorman, poses for this photograph outside a Mount Auburn streetcar. The other gentlemen are most likely associates of the Cincinnati Inclined Plane Company. (Courtesy of Earl Clark.)

MOUNT AUBURN INCLINED PLANE.

The hump of the Mount Auburn, or Main Street Incline, can be seen in this early illustration. This was the only incline that had a change in grade. The upper station was located in what is now Jackson Hill Park, just west of Auburn Avenue. (Courtesy of Bill Van Doreen.)

In 1878, the plane was rebuilt. The fixed cabs were converted to open platforms so that streetcars could be carried as well as passengers. The hump was somewhat straightened, and the track gauge was increased. Heavier engines, duplicate throttles, and reversing mechanisms were introduced. Three days after the Mount Auburn plane reopened, a pending lawsuit against the Cincinnati Inclined Plane Company was settled in favor of the plaintiff, the telephone company. Judge William Howard Taft upheld the claim that the trolley wires interfered with the phone service in Mount Auburn. Cincinnati streetcars had to convert to a double-wire system. This was a disappointment to the industry, since the single-wire system was the most economical. The Ohio Supreme Court reversed the decision the next year due to new evidence that the tracks, if properly bonded, could carry the ground current without affecting other electrical systems. (Courtesy of Earl Clark.)

The 1884 Cincinnati Atlas shows the location of the bottom depot of the Mount Auburn Incline at Mulberry and Main Streets. Passengers were becoming dissatisfied with the Cincinnati Inclined Plane Company. The company charged a 5¢ fare from Fifth and Main Streets to the bottom station at Mulberry Street, another 5¢ for the incline, and 5¢ more for a transfer at the top. Other street railway companies used much of their profits to purchase new cars and build extensions. Moreover, to save money, the Cincinnati Inclined Plane Company hired young boys to drive and conduct the Mount Auburn Incline. These young men were often bad mannered and disrespectful to customers. Eventually, people began to complain.

This sketch by an anonymous artist illustrates the worst tragedy in the history of Cincinnati's inclines. On October 15, 1889, just after noon, seven passengers boarded the car for Mount Auburn at Mulberry and Main Streets. As the car neared the head house, the operator applied the brakes in his usual manner. Rather than slowing, the machinery continued to turn, and the car smashed into the head house. Before frightened passengers could escape, the hoisting and safety cables ripped from the truck. As the force of the engines gave way to gravity, the car hung for a moment in mid-air before beginning its maddening plunge. At the bottom, the body of the car crashed into a grocery store at the corner of Mulberry and Main Street, and the iron gate at the lower station was flung 60 feet. According to eyewitness accounts, "the roof flattened out like a sheet of newspaper" and soared 100 feet down Main Street. One passenger survived. The conductor, William H. Birt; the motorman, James McManning; and six passengers were killed. Among the victims were a teacher, a retired judge, and a little girl named Lillian. Hon. William Dickson, who was nearly 72 years old, was a personal friend of Pres. Abraham Lincoln. Defective machinery and lack of safety equipment was blamed. Despite this, the operator, Charles Goble, was held responsible.

Although the Mount Auburn Incline continued to operate, a series of events sealed its fate. The company was again sued, this time by the city, claiming that it had violated its steam railroad charter. Ridership declined when the Cincinnati Street Railway Company began running a streetcar to the area. The panic of 1893 caused an economic downturn, and the Cincinnati Inclined Plane Company faced a buyout. On April 14, 1898, Charles H. Kilgour, a man with interest in both the Cincinnati Street Railway Company and the Mill Creek Valley Street Railway, bought the Cincinnati Inclined Plane Company property. On June 4, 1898, the plane was closed for repairs but never reopened. (Courtesy of Bill Van Doreen.)

While the Mount Auburn plane was on its way out, other inclines were being built in Cincinnati. Mount Adams was the perfect place for an inclined plane. Besides the breathtaking view of the river, the hilltop seemed to have a refreshing breeze at times when the city was overcome with stagnant smoke. (Courtesy of Bill Van Doreen.)

The Mount Adams Incline, which opened on March 12, 1876, carried passengers from the foot of Lock Street to the summit at Ida Street near the future site of the Rookwood Pottery. It was 945 feet long, 230 feet high, and cost over $200,000 to build. The incline passed over three streets: Baum Street near the bottom, Oregon Street further up, and Kilgour Street close to the top. The Mount Adams Incline had the longest life of any of the hillside railroads, 70 years. (Courtesy of Earl Clark.)

This illustration from about 1888 shows the Mount Adams Incline from Fourth and Main Streets. Mount Adams got its name when former president John Quincy Adams came to dedicate the nation's first observatory in 1843. By the late 1800s, the smoke and smog were interfering with the telescope's view, and it was moved to Mount Lookout.

Beautiful Eden Park, which opened on July 1, 1870, was created with land donated by Nicholas Longworth, one of the most important businessmen in the history of the city. Free to the public, it was accessible only to the wealthy, since the commoners could not afford to keep the horses necessary to make the trip from the basin area of the city up the hill. The Cincinnati Street Railway Company decided to lay tracks for a horsecar route from the top of the Mount Adams Incline, across the Ida Street bridge, and past the art museum all the way to Gilbert Avenue. (Courtesy of Phil Lind.)

The park board, intending to connect Ida Street with a new road on the northern side of Eden Park Drive, hired prominent architect Samuel Hannaford to build the monumental stone bridge at the entrance to Eden Park in 1872. However, it ran out of money before it was finished. The Cincinnati Street Railway Company decided to finish the project and in 1878 erected the handsome iron superstructure on top of the existing bridge. The route now ran north from the top of the incline, across the Ida Street bridge, past the western side of the art museum, and on across the newly improved Eden Park entrance bridge. Eden Park, now enjoyed by everyone, was and still is a destination in itself. People came in carriages to visit the art museum, take in the view, and ride bicycles. (Courtesy of Phil Lind.)

Nicholas Longworth, the original landowner on the hill, planted his vineyards to cover the barren, ugly hillside that was left when the original settlers used the trees for their homes. Although Longworth was quite wealthy, the neighborhood of Mount Adams was neither exclusive nor pretentious. This postcard shows the way that, from a distance, the incline seemed to bisect the colony of small, modest homes. Rookwood Pottery is on the left side of the hilltop; Immaculata Church is on the right. Holy Cross Monastery, once the site of the Mitchel Observatory, occupies the highest point of the hill. (Courtesy of Tom White.)

Like the Mount Auburn Incline, the route to Mount Adams began at Fountain Square, the center of city life. *The Genius of Water*, as the Tyler A. Davidson fountain is called, was a gift to the city from Henry Probasco, a prominent businessman in 1871. The fountain, a recognizable icon of the city of Cincinnati, occupied the center of Fifth Street at Vine Street until 1971, when it was moved to the north side of Fifth Street. (Courtesy of Larry Fobiano.)

The Mount Adams streetcar meandered from Fountain Square to the foot of Mount Adams, where it crossed a small bridge over the runoff of the Mill Creek before continuing to the bottom station at Lock Street. (Courtesy of Bill Van Doreen.)

The Mount Adams Incline was enormously popular, and the bottom station of the Eden Park Railway eventually got a face-lift. (Courtesy of Phil Lind.)

Both departing and arriving cars shared a single track at the bottom of the Mount Adams Incline. To eliminate confusion, a Nachod signal, a type of trolley signal, was used. Usually the departing car got the go-ahead. When the approaching car got the signal to proceed, the motorman rolled it onto the waiting lift, or truck, which rested in a pit at the bottom. Once the car was on the lift, he got out and chocked the wheels to keep it from rolling. (Courtesy of Phil Lind.)

The waiting room, visible through this doorway, was constructed when the management became concerned with the safety of the passengers at the lower station. (Courtesy of Phil Lind.)

The truck is lifted out of the pit slowly, gradually gaining speed. The trip took 2 minutes and 20 seconds. Six times every hour, 19 hours a day, two trucks went up and down the plane. Residents became so accustomed to the incline that often they hardly noticed it. (Courtesy of Phil Lind.)

Once the passengers were lifted above the rooftops, the city dominated the view. The immediate surroundings of the track, though, were more like a back alley in the working-class neighborhood of Mount Adams. Mops commonly hung over railings as they dried, and a households trash and under things were often on exhibit for patrons of the incline. Children who rode the incline could usually be found at the railing, as these photographs show. (Courtesy of Bill Van Doreen.)

Engineer Forrest Himes inspects the machinery in the basement of the head house in this photograph, which was taken from the employee newsletter in 1941. The boilers worked two at a time to supply the steam for the engines, which cranked two 14-foot-diameter cast-iron and oak winding drums. The drums pulled the long, continuous hoisting cables, which were connected to the platforms, in opposite directions. At the top of the incline, elevating sheaves, cast-iron pulleys that were nine and a half feet in diameter, guided the cables in and out of the cellar. Two large safety sheaves in the center of the room wound the safety cable that counterbalanced the trucks. When one of the lifts ascended, the other descended. The same man who planned and built the Monongahela Incline in Pittsburgh designed the Mount Adams Incline. (Right, courtesy of Bill Van Doreen; below, courtesy of Phil Lind.)

People in the descending truck had this view of the city and the escalating lift. Likewise, passengers making their ascent watched as the advancing truck slid down the track toward them. Every second, the faces of the passengers on the other truck became more distinct. For an instant, they were side by side. Then as quickly as they came together, they retreated. The two trucks passed each other near the point where the incline passed over Oregon Street. (Above, courtesy of Tom White; below, courtesy of Phil Lind.)

In 1925, overhead carriages for the trolley wires were installed. Prior to this, the conductor had to raise and lower them each time the car drove on or off the incline. There was no power to the carriage, and at night, the cars were dark until contact was reestablished at the top and bottom of the plane. Anyhow, the passengers preferred to have the lights off, since it was easy to see the changing perspectives of the lit-up city below. (Courtesy of Fred Bauer.)

Sunday was the day for fun and relaxation. An advertisement on this streetcar makes a pitch for Coney Island, one of the city's two amusement parks. The other, Chester Park, was very popular. Both destinations had rides, games, food, and entertainment. The Cincinnati Zoological Gardens, just another out-of-the-way attraction for most city dwellers, enjoyed overnight fame when the Zoo-Eden line began bringing passengers by way of the Mount Adams Incline. The zoo was the home of the Cincinnati Symphony Orchestra for a time, and weekly concerts were given there. A restaurant on the grounds made an all-day visit convenient. The photograph below shows a streetcar on Spring Grove Avenue in front of the entrance to Chester Park. (Above, courtesy of Bill Van Doreen; below, courtesy of Phil Lind.)

A good illustration of the Mount Adams plane shows the pilothouse inside the upper station. The head house was typical of Victorian-era commercial buildings made of brick and stone with a slate roof. It was 128 feet long and had a large baroque dome and side wings for servicing the cab cars, which were fixed at the time. At the rear of the complex is the Highland House, an entertainment complex. The building to the right of the track is a summer stage. At the extreme right is a repair shop.

The Cincinnati Street Railway Company was a little too hasty in constructing the plane over Kilgour, Oregon, and Baum Streets, and in retaliation, the city ordered the company to construct iron bridges and provide stairways leading from these streets up to the tracks so passengers could enter and depart the plane in several locations. The Cincinnati Street Railway Company finally persuaded the councilmen that this would be dangerous for both pedestrians and passengers. Eventually the city realized that its demands were unreasonable. (Courtesy of Earl Clark.)

The head house looms in front of passengers as they advance toward the top. The large brick chimney on the east side over the coal cellar had a platform with a rail, and waiting passengers often gazed at the city and watched as the lift they would soon board made its way toward them. (Courtesy of Phil Lind.)

The incline had the same effect on men and women, young and old. Two young men watch, mesmerized, as the track moves beneath their feet in this photograph taken August 4, 1935. Sharing the railing with them is a couple and their young girls. (Courtesy of Earl Clark.)

Passengers were accompanied by power lines and wooden fences as they watched the city unfold. Many of the passengers had never before left the confines of the city. Once above the rooftops, the passengers saw a side of the city previously enjoyed mostly by chimney sweeps. The novelty of this new perspective was one reason for the incline's success. (Courtesy of Phil Lind.)

Like a pilot, the operator brings the lift in for a gentle landing when it nears the top of the plane. This photograph, taken in August 1940, shows the platform and the undercarriage of the lift from the upper landing. (Courtesy of Phil Lind.)

Looking through the head house toward Ida Street, the Rookwood Pottery is on the left. The Highland Towers apartment building occupies the space where the upper station once stood. (Courtesy of Phil Lind.)

Streetcars leaving the upper station of the Mount Adams Incline rumbled across the rickety old Ida Street bridge. The above photograph was taken on February 14, 1931, before the bridge was replaced. The photograph below, taken six months later on August 14, 1931, shows the double arches of the new Ida Street bridge. Holy Cross Monastery dominates the hilltop. Now a condominium building, the monastery occupies the original site of the Mitchel Observatory before it was moved to Mount Lookout. The Rookwood Pottery is at the far right just above Monastery Street, which was originally called Observatory Road. The train in the foreground carried passengers from Cincinnati to Lebanon. (Courtesy of Phil Lind.)

Just around the corner from the Ida Street bridge was the art museum. The Zoo-Eden line ran along the edge of the hill, past the art museum, and across the Eden Park entrance bridge. (Courtesy of Phil Lind.)

35

In 1879, the upper station house was remodeled, and the old dome roof was replaced with a hip roof. A new broad-gauge track structure that could support 20 tons was installed. Since the new tracks required an opening that was 30 feet larger than the original, both the head house and the machinery cellar were enlarged. The renovation took six months, and the plane was shut down from November 1879 to April 1880. When it reopened, hundreds came to ride. (Courtesy of Bill Van Doreen.)

Passengers about to ride down the Mount Adams Incline had this thrilling view from the edge of the upper station. Although it must have been intimidating for some, the Mount Adams Incline was considered the safest and most well built in the city. Safety mechanisms on the tracks at the top and bottom landings called keepers acted like anchors to keep the car from rolling down the plane. (Courtesy of Phil Lind.)

A streetcar makes its way up as another descends in this photograph, taken in July 1940. (Courtesy of Phil Lind.)

The pit at the Lock Street station stands out against the snow in this photograph. Service on the Mount Adams Incline began at 5:30 a.m. and ended at 12:45 a.m. (Courtesy of Phil Lind.)

Children play on the snowy slopes of Mount Adams near the incline. George Kerper, president of the Mount Adams and Eden Park Inclined Railway, did his best to make the incline as comfortable and convenient as possible for his passengers. Affectionately known as the Renaissance man of the street railway business, he provided stoves to heat the cars in the winter, voluntarily reduced fares, and constantly pushed the industry to new heights. Naturally, he was beloved by the public. (Courtesy of Earl Clark.)

A child watches the lift slide into the pit on Lock Street. While the Mount Adams Incline was a tourist attraction, it was also something of an alley. Trash, billboards, and underwear were part of the everyday scenery. (Courtesy of Phil Lind.)

The News

VOL. IV NO. 12 DECEMBER 1930

A blanket of snow covers the roof of the Rookwood Pottery, a world-renowned manufacturer of tiles, ceramics, and pottery. In the late 1800s, the pottery offered classes for children. A streetcar stops in front of the upper station of the incline. (Courtesy of Phil Lind.)

The Bellevue Incline, which opened in 1876, passed by McMicken Hall, the first college of the University of Cincinnati. A medical school, it shared a freezer for cadavers with the Schoenling Brewery, just down the hill. The young male students often got a thrill from waving body parts at the female passengers who passed by on the incline. Eventually, people began to complain. (Courtesy of Phil Lind.)

The horsecar line that ran from Fountain Square to McMicken Avenue used the Bellevue Incline. Bill Groff, the man in the front of the car, drove the mules from Mohawk Bridge to Vine Street along McMicken Avenue. Mules were used quite often in the horsecar business. This picture was taken in the early 1880s. (Courtesy of Phil Lind.)

The track of the incline is seen through the bottom station. There are conflicting figures on the length of the Bellevue Incline. Authors Richard M. Wagner and Roy J. Wright believed it to be "either 980 or 1020 feet long." (Courtesy of Phil Lind.)

The bottom depot of the Bellevue Incline had a turntable, flush with the street, in McMicken Avenue, just to the right of the intersection of Elm Street and McMicken Avenue. Streetcars moved from one track to the other by means of track switches. (Courtesy of Phil Lind.)

Workers stand in front of the original shack of the bottom station in this photograph taken in the late 1800s. The Bellevue, or Elm Street Incline, was officially called the Cincinnati and Clifton Inclined Plane Railroad. Advertising that it was the "only through route to the Zoological Garden, Burnet Woods and Clifton," it carried passengers from the foot of Elm Street to Clifton via the summit at the end of Ohio Avenue. Those were the days when Burnet Woods was a destination. In September 1890, the plane was renovated to carry horsecars and streetcars, and the station was updated. (Left, courtesy of Phil Lind; below, courtesy of Fred Bauer.)

Like the Mount Adams Incline, the lifts of the Bellevue Incline were counterbalanced, passing each other over Clifton Avenue. (Courtesy of Earl Clark.)

The double trolley poles of a streetcar can be seen behind the gate of this lift. The poles, which were tensioned, stood straight up in the air so they could ride on the trolley wires in the streets. (Courtesy of Phil Lind.)

Bellevue Incline, Cincinnati, O. Length, 1020 feet. Hauling capacity, 20 tons. Height, 395 feet.

Passengers left the smoke of the city behind when they boarded an incline bound for the hilltops. The stone piers that supported the wooden trestle stood on either side of Clifton Avenue. The pier on the right side of the bottom photograph is still there. (Courtesy of Bill Van Doreen.)

The bottom depot was remodeled in September 1890. The gateman, pictured here wearing a vest, collected fares from passengers, saw that they got on the platform with no problems, and closed the gate. A two-bell signal to the operator meant that everything was ready. (Courtesy of Bill Van Doreen.)

The bottom station stood on the northeast side of McMicken Avenue near Elm Street. (Courtesy of Phil Lind.)

Passengers disembark from a streetcar at the top of the incline. The upper station of the Bellevue Incline had two smokestacks. (Courtesy of Phil Lind.)

of Elm Street and McMicken Avenue can be seen clearly in this photograph, which was taken on April 25, 1948. (Courtesy of Phil Lind.)

From the top of the incline, the streetcar turned north onto Elmont Avenue, then onto Ohio Avenue, and east onto McMillan Avenue. From there, it continued to Woodburn Avenue and Walnut Hills. The fabulous Bellevue House, the hilltop entertainment complex at the Bellevue Incline, occupied the southwest corner of the hilltop. The smaller track on the left is a coal siding, used to deliver coal to the powerhouse. (Courtesy of the Cincinnati Transit Historical Association.)

49

A streetcar leaves the upper station and heads for Ohio Avenue in what is now Bellevue Hill Park. The days of the streetcars on Ohio Avenue were numbered, however, when an inspection revealed that the plane needed extensive repairs to its trestle and foundation. The report deemed it only "50 percent stable," but the Cincinnati Street Railway Company could not afford to make all the necessary repairs. When the city took over operations of the street railways in 1925, the Bellevue Incline was excluded from the plan, and it closed in 1926. During the flood of 1937, the top station house was used by the Cincinnati Street Railway Company to store streetcars. The building was destroyed in a fire; the wooden streetcars provided much of the fuel. Although the city had plans to beautify the hillside, they were never realized. The view at the overlook is all but obscured, and the piers, stripped of their rails, lie forgotten in the brush. (Courtesy of Phil Lind.)

The Fairview, or Crosstown Incline, crowns the hill above Central Parkway, its 80-foot smokestack pointing toward the skies. The Fairview Incline was built in 1892 with parts salvaged from the 1890 remodel of the Bellevue Incline. It was the shortest of the five inclines, between 633 and 700 feet. Part of it was built on trestle and some on solid rock. It was the only incline that did not have a resort at its summit. (Courtesy of Phil Lind.)

Looking north from Freeman Avenue, the Fairview Incline stretches down the western side of the hill from Fairview Heights to the landing on McMicken Avenue in this photograph, taken on March 30, 1953. Christian Moerlein, a wealthy beer baron, was one of the first residents of Fairview Heights. The home he bought as a wedding present for his daughter houses Lenhardt's Restaurant on McMillan Avenue. (Courtesy of Phil Lind.)

The No. 23 Fairview Heights route was modified more than once to accommodate the changing needs of the city. Beginning in 1895, the route ran from downtown at Central Parkway to the bottom landing of the Fairview Incline on McMicken Avenue. From the top of the incline, it traveled along Fairview Avenue to Straight Street and Clifton Avenue. From there, it turned left, traveling north along Clifton Avenue on the western side of Burnet Woods, the southern part of which became the University of Cincinnati campus. From there it turned around and came back. Streetcars turned around by pulling into a Y, a designated turnaround location, backing up, and pulling back into the street. There were several variations of Y turnarounds on the different routes. (Courtesy of Phil Lind.)

The Fairview Incline was the only one in the city that began carrying streetcars and ended with fixed cabs. Although it is rumored that plans were drawn for a bottom station at the Fairview Incline, it was never built. A simple landing on McMicken Avenue with a pit, a gate, and a shack was all that ever existed. (Courtesy of Phil Lind.)

Motorman James Glazer guides one of the first crosstown cars to run on the Fairview Incline onto McMicken Avenue in this photograph, which was taken between 1905 and 1915. The conductor, Mr. Krueger, stands on the sideboard. William Backus, the gateman, stands out of the way near two young boys. (Courtesy of Phil Lind.)

Because of the Fairview Incline, it was now possible to travel from the east side of the city to the west. The route became the crosstown line and ran from the bottom of the incline down McMicken Avenue, across the Brighton Ramp, and over the old Harrison Avenue Viaduct to State Avenue. At Eighth Street and State Avenue, the Price Hill Incline extended travel to Delhi and Western Hills. Passengers on the *Hiawatha*, an observation car, enjoy the view of the Mill Creek Valley from the top of the incline. A ride on the incline on either the *Hiawatha* or the *Maketewah*, another observation car, was like riding in a convertible. (Courtesy of Phil Lind.)

A 1921 inspection revealed defects in the Fairview plane, and it was condemned for streetcar use. The incline was temporarily closed on August 21, 1921, while fixed cabs were mounted on the truck body, and for a time, the incline carried only passengers. The company, faced with spending $55,000 to rehabilitate the plane, chose instead to spend $85,000 to extend McMillan Avenue from its former terminus at Fairview Avenue down the hill to Central Parkway to replace the incline. The extension was completed in December 1923, and the incline was shut down forever on December 24. After the incline closed, the crosstown line merged with another line, and the route now ran west across the Harrison Avenue Viaduct and south to the intersection of Eighth and State. Traveling east, the line ran up the new extension of McMillan Avenue to Woodburn Avenue, then to Chapel Street, Alms Place and Yale Avenue, ending at Gilbert Avenue. In 1932, crosstown cars began using the new double-decker Western Hills Viaduct, which replaced the old Harrison Avenue Viaduct. (Courtesy of Phil Lind.)

The Price Hill Incline was Cincinnati's second hillside railway. The barren hillside would soon be covered with houses along Glenway and Warsaw Avenues, many of them built with materials that were transported on the incline. (Courtesy of Phil Lind.)

Invitations to the grand opening of the Price Hill Incline on July 14, 1875, were issued to the public. William Price built the incline with money from his father, Gen. Rees E. Price. William Price was the grandson of the pioneer Evans Price, who settled the hill in 1807. The Price family owned so much of the hill that it was called Price's Hill. (Courtesy of the Price Hill Historic Society.)

The Price Hill Incline had two double-track systems, one for passengers, on the left, and the other for freight, on the right. The freight plane, the only one of its kind in the city, opened one year after the passenger plane in 1876. Like the other inclines, the lifts were counterbalanced. When one went up, the other went down. This photograph, taken in 1905, shows the pit on State Avenue. (Courtesy of Phil Lind.)

A horsecar to Riverside and Sedamsville waits at the bottom depot of the Price Hill Incline at Eighth Street and State Avenue in this photograph, taken around 1880. Horses sometimes stood in line for blocks as they waited to board the platform. The approach began at the foot of Eighth Street, which leads east to the city in the opposite direction. Horsecar lines that ran from the city over the treacherous Mill Creek Bottoms to Price Hill were called Price's Chariots. A sign on the station house advertises property on the hill. (Courtesy of the Price Hill Historic Society.)

The staggered stone piers of the 800-foot-long planes resemble a roman bridge in this photograph. (Courtesy of Bill Van Doreen.)

The Price Hill Incline was the only family owned and operated incline in the city. William Price named the passenger cars *Lily-of-the-Valley* and *Highland Mary* after his sisters. The freight side of the incline could accommodate up to four horse-drawn wagons. The original head house of the passenger plane had an observation tower. The tower was removed when the building was remodeled. (Courtesy of Bill Van Doreen.)

The Price Hill planes were the steepest of the five inclines in Cincinnati, with a nearly 47 percent grade. Rising to a height of 350 feet, together they cut an 80-foot-wide path down the hill. (Courtesy of John H. White Jr.)

No. 517. Price Hill Incline-plane, Cincinnati.

Four bridges, each spanning 50 feet, stretched across Warsaw and Maryland Avenues. Although the steel was scrapped when the incline was demolished, many of the stone piers, including these at Maryland Avenue, still stand. (Above, courtesy of John H. White Jr.; below, courtesy of Bill Van Doreen.)

Wreck of Price Hill Incline Plane, 1907, Cincinnati.

The only serious wreck on the Price Hill Incline happened in October 1906. Nineteen-year-old Joe Strassell boarded the freight plane with his two horses and a load of manure. He shared the car with another man, his two horses, and a load of sand. The five-minute ride brought the car within six feet of the upper station. Suddenly, the car lurched, and the cable swished back and forth. Strassell somersaulted backward into his pile of manure and awoke at the bottom to see a coal dealer trying to comfort one of the mangled horses. He begged for someone to shoot them, and a policeman put them out of their misery. An instant hero, Strassell celebrated his fame with a complimentary bowl of soup. Someone even loaned him a derby to wear home. The important thing was that he covered his head, never mind that he must have smelled of manure. (Courtesy of Bill Van Doreen.)

The Eighth Street Viaduct made transportation between the downtown area and Price Hill easier. The raised roadway carried traffic over the Mill Creek Bottoms, which was prone to flooding and occupied by train yards. The Eighth Street line of the Cincinnati Street Railway began running directly up the hill via Warsaw Avenue, bypassing the incline. Likewise, the Elberon line carried passengers conveniently from the south side of Price Hill to the city. Rather than waiting for the incline, many people preferred to take the quicker routes. (Courtesy of Bill Van Doreen.)

Fares from hauling teams had declined so much that by 1929, the company could no longer afford to run the freight plane, and it was shut down. Expensive repairs to the machinery, track, and the sliding hillside ate into the profits. Never the less, despite the fact that the incline was costly to maintain, there was still a large demand for transportation to the west side. (Courtesy of Phil Lind.)

By the 1940s, the original timbers had become so rotten that they would not hold a spike. On July 31, 1943, the rails bent, and a car jumped the track. No one was injured, but the city ordered repairs in addition to what the company had already begun. Approximately $29,000 was needed to rehabilitate the plane, which many people still depended upon. Mr. Rose, the president of the Price Hill Inclined Plane Company had been concerned about the company's finances for quite some time. In 1927, he wrote to Walter Draper, the president of the Cincinnati Street Railway Company, offering to sell the freight plane to the Cincinnati Street Railway Company to haul their buses. Draper never took Rose up on his offer. The incline was finally closed in December 1943. Eventually the Price Hill House, the hilltop resort, was torn down, and the radio station WSAI erected its transmitter on the site. (Courtesy of Phil Lind.)

Passengers dressed for a night out ride in the observation car, the *Maketewah*, to the Highland House. By the time they arrived at the upper station, they were invigorated from the rushing air, the trainlike motion of the incline, the lights of the city, and the river. Ready for fun, they landed at the Highland House. Every night, the radiance of the illuminated resort and the moving lights of the incline contrasted with the silence and stillness of the dark circle of hills. From the stifling city, the fluttering streamers at the top were proof of the persistent breezes that frequented the hilltop. (Courtesy of Phil Lind.)

The owners of the Mount Auburn Incline thought that their venture might be more successful if there was some sort of attraction at the summit. Their concern was in vain, since the incline carried close to one million passengers to the top of Mount Auburn its first year. Even so, they could not have fully realized the effect that this rather plain building, the Lookout House, would have on the city for generations to come. (Courtesy of Phil Lind.)

Frank Harff, the proprietor, was a former saloonkeeper and a man ahead of his time. Harff's carnival-style theatrics drew thousands every weekend to the top of Mount Auburn. He even imported a giant whale in a specially made tank. Harff circulated fliers, which read, "The third, last, and only genuine living white whale! See it today, for tomorrow it may be dead." When it did die a month later, the rotting corpse of the poor beast drew thousands of curious people to the Lookout House.

Two

HILLTOP FUN

Top Station, Cincinnati Incline Plane Railway Company, surrounding facilities and the Lookout House. From the Sanborn Fire Insurance maps

This map, taken from the Sanborn Fire Insurance Maps, shows the location of the Lookout House complex at the top of the Mount Auburn Incline. Jackson Hill Park now occupies the area where the Lookout House and grounds once stood just west of Auburn Avenue from Malvern Place and south of Christ Hospital. In addition to music, dancing, food, and beer, the fresh air and the view were supplemented with regular fireworks and hot air balloon rides.

The Lookout House was the crowning jewel of the city until 1880, when the Highland House opened and surpassed it in popularity. The wealthy residents of Mount Auburn, who had enjoyed the privacy of their exclusive neighborhood for some time, were complaining about the music and the carousing that took place practically in their own backyards. Frank Harff took over the management of the Highland House in 1877. Harff was so well liked that when he died in

October 1886, thousands of people attended his funeral at the Highland House. Both the incline and the Highland House, symbols of merriness, were draped in black to mourn his passing. At the time, German culture and language was so pervasive in Cincinnati that the service was held first in German, then in English. (Illustration from the 1887 Souvenir of Cincinnati Attractions.)

Passengers boarded the horsecar to the Highland House and the Mount Adams Incline at the intersection of Reading Road and Oak Street at the site of the old Bethesda Hospital. The horsecar on the left, part of the Mount Adams and Eden Park Incline Railway, carried passengers to and from the Mount Adams Incline in this photograph from around 1880. The smaller horsecar on the right, called a chariot, ran from downtown to Reading Road, connecting with the Eden Park Incline Railway car at this intersection. Although many horsecar lines ran on tracks, this one did not. (Courtesy of Phil Lind.)

The mood of the Highland House was one of enjoyment and good taste. Men and women, dressed in their finest, gathered in groups on the balconies of the courtyard to talk, dance, and drink "the finest beer from around the world." Couples enjoyed strolling in the gardens, which had marble, stone, iron, and bronze statues, fountains, and "lush flowerbeds." A canopied belvedere, or summer pavilion, was constructed on the east side. High and open, it seated 7,000 and was used for dancing, roller-skating, balls, and public picnics. Even in the dead of winter, the December 21, 1876, grand opening of the Highland House caused excitement. Frank Harff abandoned his carnival-like theatrics and turned the Highland House into an amusement palace that was second to none. He imported premier bands from around the world, and Cincinnati became known as the "Paris of America." This image is from the *Scientific American* supplement of April 20, 1878. (Courtesy of Phil Lind.)

A young boy contemplates the city and his parents enjoy a drink while his sister reaches for her mother's in this illustration drawn around 1880. The Highland House was a place where families, couples, and singles alike gathered to celebrate the day. (Courtesy of Earl Clark.)

Two bronze fountains bubbled in the heart of the 135-foot-long dining room. A visit to the Highland House meant a fine meal, a breathtaking view, and a cold glass of beer. From the vantage point of one of the many balconies, patrons sat on wicker chairs and enjoyed a dark beer or a good Moerlein lager and a smoke as they observed the city, the boats on the river, and the hills. (Courtesy of Earl Clark.)

AMUSEMENTS.

HIGHLAND HOUSE

MOUNT ADAMS.

GRAND OPENING

—ON—

Thursday Night, December 21,

—WITH—

CURRIER'S CELEBRATED REED BAND.

PROGRAMME.

PART I.
1. Grand March, "Le Prophet".............Meyerbeer
2. Overture, "Die Frau Meisterin"...............Suppe
3. Waltz (the latest), "Upright Life"............Strauss

PART II.
4. Overture, "Maritana"............................Wallace
5. Fantasia (descriptive), "The Prodigal Sou"..Dawson
 The latest musical novelty, "Instrumentation"..................By C. M. Currier
6. Polka characteristic, "La Gracieuse".........Herde

PART III.
7. Overture, "Brewer of Preston".................Adam
8. Waltz, "Sounds from the Vienna Woods"..Strauss
9. Bouffe Selection, "Girofle-Girofla"...........Lecocq

PART IV.
10. Quodlibet Populaire.........................Fr. Zikoff
11. Serenade for Flute and Horn....................Tittl
 Messrs. Heckle and Kuhn.
12. Finale, "Down the Incline"..................S. Hook
 C. M. CURRIER....................Conductor.

This elegant building, located at the head of Mount Adams and Eden Park Incline Railway, will be open to the public on and after this evening.

Its appointments are so complete in every respect for the comfort and convenience of the guests, that it will only have to be seen to be appreciated.

The Beer Hall, Billiard-Room, Bowling Alleys and Restaurant will be in charge of competent attendants, and every attention will be paid to the comfort of visitors.

1t **B. F. STARR, Proprietor.**

From *The Cincinnati Enquirer*, 1876

Currier's Band was the entertainment for opening night at the Highland House. A specially written finale, called "Down the Incline," celebrated the new breed of entertainment that belonged to Cincinnati alone. The popular Theodore Thomas Band was such a hit that his concerts regularly drew crowds of 8,000. Such a huge crowd was expected for the September 10, 1887, performance that Frank Harff gave notice in the paper recommending advance arrival, since the incline could carry only 2,000 people per hour. A *Cincinnati Commercial* reporter recalled the "lovely summer nights of last year when all of Cincinnati sat on the terrace and sipped iced beer, and listened, entranced, to the Thomas orchestra—to the dreamy, delicious music of Strauss and the haunting symphonies of Beethoven." (Courtesy of the Cincinnati Transit History Association.)

ENTERTAINMENT.

Millers' International Exhibition

AND

GRAIN CONGRESS,

AT THE

HIGHLAND HOUSE,

THURSDAY EVENING, JUNE 3, 1880,

AT 8 O'CLOCK.

SEIDENSTICKER'S BAND.

PROGRAMME.

I.

1. Grand March .. Parlow
2. String Quartett—B Flat Mozart

Messrs. Jacob Bloom, Max Bendix, Chas. Baetens and Theo. Hahn.

3. Overture—Maritani ... Wallace
4. Selections—Preciosa Weber
5. Cornet Solo ... Levy

Mr. Ruckel.

II.

6. Overture—Pique Dame Suppe
7. String Quartett— { a Night Song Vogt
 { b Menuett Bocherini
8. Scotch Airs ... Bonisson
9. Waltz—Wiener Kinder Strauss

III.

10. Overture—One Day and One Night in Berlin Suppe
11. String Quartett ... Hayden
12. Cornet Solo .. Hartman
13. Potpourri—Martha .. Flotow
14. Finale ... Strauss

Porter & Williams, Printers, Hopkins' Music Hall, 169 W. Fourth St., Cin.

From an advertising card

Although the place needed no advertisement, this flyer for an Independence Day concert at the Highland House was circulated to Cincinnatians who were eager to get out of the hot city and spend the day on the hilltop. The crowd that insisted on celebrating the 1877 holiday at the Highland House almost caused a riot because the incline could not transport them quickly enough. The police had to be called to the bottom of Lock Street, where the impatient mob began swarming up the hillside on foot. At the top, the scene was chaos. Waiters inside could not move. Outside, the largest hot air balloon in the country prepared to float out over the city. Two brass bands out on the belvedere "blasted away at one another." The hilltop offered a unique vantage point for the fireworks. According to one account, they were enjoyed mostly by those who stood on the tables and blocked the view for everyone else. (Courtesy of the Cincinnati Transit Historical Association.)

Frequent parties were held at the Highland House. One afternoon, a bakery wagon delivering pastries to a children's party boarded the incline. The unbalanced load caused a mechanical failure and the platform fell. Although the driver escaped, the horses could not jump over the high fence and were crushed. Although these things sometimes happened, the Highland House got plenty of good press. (Courtesy of Phil Lind.)

An illustration of the interior of the Highland House shows its potential as a place for socializing. The main hall, or beer hall, occupied most of first floor, had two large fountains, and could seat 2,000. A long bar joined the main hall in the center near the stairs. Opposite the bar was a recessed alcove for the band. A billiard room had four tables. The architects of the Highland House thought of everything. There was a cloakroom and an elevator to the second floor. Upstairs, the ladies' parlor had its own powder room. The ballroom, or dance hall, had its own bar and music stage. The large dining room had a butler's pantry for servers. There was even a smoking room sandwiched between two verandas. Balconies on every side, including one on the third floor, took advantage of some of the best views in the city. The basement housed a kitchen, a laundry, beer vaults and a wine cellar, and a bowling alley with four lanes. (Courtesy of Earl Clark.)

Excited passengers crowd together against the railing rather than remaining inside the streetcar for the two-and-a-half-minute ride up the hillside. The trip was made by many. A *Cincinnati Commercial* reporter in 1880 wrote, "It is good for one to sip beer at the Highland, not especially for the beer, but because it is a part of the landscape . . . a thing in keeping with the scene . . . and you leave a little regretfully coming down to take up the plain prose of life again." With the end of the Gay Nineties came the Sunday closing laws that forced the hilltop houses out of business, and the Highland House was razed in 1895. (Courtesy of Phil Lind.)

In 1876, the same year that the Highland House came on the scene, the beautiful Bellevue House made its debut at the top of the Bellevue, or Elm Street Incline. This view is from near the intersection of Central Avenue and Mohawk Street in Brighton. (Courtesy of Phil Lind.)

The approach to the Bellevue House was very dramatic. Passengers on the 1,000-foot-long incline watched with anticipation as the fabulous Bellevue House grew larger before their eyes. The wide esplanade on top of the wall was filled with people who were walking, talking, and watching the approaching incline. Through the short tunnel in the wall, the head house came into view, and after a brief passage under the esplanade, they emerged on the other side. Once they had disembarked, they could take the streetcar on to Burnet Woods or the zoo, but the Bellevue House was a destination in itself, and many chose to stay. (Courtesy of Phil Lind.)

The Tudor-style Bellevue House was designed by James McLaughlin, whose list of accomplishments includes the Cincinnati Art Museum. The Bellevue House was considered the most architecturally pleasing of the four hilltop houses. A long bar in the entrance hall served Cincinnati-brewed Christian Moerlein beer exclusively. After a drink or a meal, guests proceeded to the octagonal dance hall, which was the heart of the resort. The soaring ceilings of the nearly 90-foot space were filled with light from clerestory windows three stories above. An orchestra platform in the center of the room was surrounded by a ring of wooden columns. Bay windows and doors on every side opened onto the 12-foot-wide verandas. In the winter, guests enjoyed bowling in the lower level, which had plenty of windows. (Courtesy of Phil Lind.)

The illustration below, taken from the 1887 Souvenir of Cincinnati Attractions, shows a scene at the Bellevue House. Ladies walk on the arms of their men toward the summer theater and dance pavilion at the rear of the complex as waiters in white coats carry beverages to guests. In addition to theater, music, and dancing, patrons could have a drink or a meal, bowl, or picnic on the grounds. (Courtesy of Tom White.)

The hilltop resorts were places to see and be seen. Elegant women carried parasols, and men carried canes. Nobody thought to leave the house without a hat in those days. A streetcar from Clifton Avenue approaches the station. The Lookout House is visible on the next hill, beyond the lamps that line the esplanade. (Courtesy of Tom White.)

Passengers on the incline passed through a short tunnel in the massive retaining wall as they drifted toward the upper station. The wall, which was built in 1883 after a series of landslides, was covered with a wide esplanade that was perfect for strolling and enjoying the view. (Courtesy of Phil Lind.)

From its 400-foot-high perch above Clifton Avenue, the views from the octagonal veranda of the Bellevue House were spectacular. (Courtesy of Phil Lind.)

The Sunday closing laws put an end to the party at the Bellevue House. The once-grand palace became rundown, and it was finally abandoned. The Cincinnati Street Railway Company began using it to store wooden streetcars, which were fuel for the fire that destroyed it on March 22, 1901. The blazing icon, perched 400 feet up on the edge of the cliff, was seen all around the city. The shelter house at Bellevue Hill Park now occupies the site that was once occupied by the Bellevue House. (Courtesy of Phil Lind.)

Meandering paths wind through the manicured European-style gardens of the Price Hill House. The house sat near the upper station, which is now occupied by the Queens Towers Apartments. Despite the fact that the very good restaurant served no beer, the Price Hill House was visited by hundreds daily. An outdoor pavilion behind the house hosted popular musicians and entertainers. Families, couples, and singles strolled along the lovely promenade, enjoyed the large fountain, rested in the many gazebos, or simply took in the stunning view. In 1899, the Price Hill House burned, but the restaurant continued until 1938, when it closed. The western edge of the promenade at the rear of the grounds became Mount Hope Road. The northern edge is now Price Avenue, and along the rim of the hill is Matson Place. (Above, courtesy of Tom White; below, courtesy of Phil Lind.)

The trees, to the left of the upper station of the incline, obscure the view of the Price Hill House. William Price's dry policy earned the hill the nickname Buttermilk Mountain, and taverns at the bottom of the hill near Eighth and State had humorous, yet appropriate, names, including First Chance Saloon, Next Chance Saloon, and Last Chance Saloon. Cincinnati's affection for good beer persisted, though, and within 10 years, the alcohol began to flow. The name was changed to the Price Hill House Saloon, and a balcony was constructed over the edge of the hillside. Often coins and an occasional bill dropped from the pockets of intoxicated patrons, who, merry with the new policy of the establishment, were oblivious. It was a gold mine for children though, who were well rewarded for their habit of prospecting on the hill. The Price Hill House fell victim to the declining traffic on the incline and closed in 1942. (Courtesy of Phil Lind.)

Three
THE MEN WHO KEPT THE RAILS

A full crew on the Mount Adams Incline consisted of an operator, an engineer, a fireman, two gatemen, and two carpenters. The gang gathers around the base of the operator's control cab, or pilothouse, which sat 10 feet above the floor of the head house. Inside his glass-windowed cab, the pilot was both completely isolated and the center of attention. The powerhouse was rebuilt after its second fire destroyed most of the building and the upper landing. Rather than trying to escape, Chris Hollinger, one of the first operators, stayed and operated the incline so that fire engines could get to the top. He was rewarded by being burned, but he survived. (Courtesy of Bill Van Doreen.)

From his vantage point near the edge of the top landing, the operator had one of the best views in the city. He had little time to enjoy it though, as his job was to concentrate on the tracks and the lifts. Every three minutes or so, the operators took the lives of Cincinnatians into their own hands. As a pilot, he had to bring the lifts in for a safe and pleasant landing. His job was complicated by the fact that he had to land not one truck but two; since the lifts were counterbalanced they landed simultaneously. Experience and training were important, but gifts of timing, a sense of speed, as well as good eyesight and sharp hearing were necessary. (Left, courtesy of Phil Lind; below, courtesy of Bill Van Doreen.)

The powerhouse, which was considered a steam plant, was required to have a licensed engineer on the premises. Engineers like Drury Knox had their ears tuned to the sound of the machinery, just as car mechanics do, and could often diagnose a problem by the sound it made. Often, when their hearing and eyesight began to fail them, the company gave them less responsibility, which also meant a smaller paycheck. Sometimes they worked as trackman, oiling switches, or directing traffic at busy intersections. Employees frequently worked well into their 80s, since neither the notion of retirement nor Social Security existed. (Courtesy of Bill Van Doreen.)

Inside his sky-high cubbyhole, the operator was surrounded by controls. Foster Carroll, an operator on the Mount Adams plane, poses for a picture in March 1948. His left hand rests on the throttle. The winding drum brakes were activated with two foot pedals. Since they were not power brakes, he had to put all his weight on them. A red warning light indicated trouble with the machinery. (Courtesy of Bill Van Doreen.)

Workman's compensation was a thing of the future. On June 15, 1915, an oiler, William Gray, fell off the plane onto Oregon Street and broke his ribs. He was kept at General Hospital for two months. Although he was off work until December 28, it is not known whether he was compensated for lost wages. Gray made 17½¢ per hour, a total of $1.75 per day. (Courtesy of Bill Van Doreen.)

> **HARLEY L. SWIFT**
> **OCT 27 1939**
> **F. HIMES**
>
> Isn't Carroll the man who is always having something like this happen— Seems to me that it is— & if I am right the trouble must be with him & not the plane. Does he do anything outside work hrs that interferes with his efficiency?

Foster Carroll nearly lost his job over an incident with the safety brake. On July 28, 1938, while he was operating the incline, the brake stuck open. He let the car coast all the way to the station and made, in his words, "an easy landing." He reported the problem to the engineer, who reset it. Again, about two hours later, the brake failed. Again it was reset. Harley Swift, the general manager of the Mount Adams Incline, instructed Forrest Himes, the supervisor, to "give Carroll three days suspension . . . He has been cautioned repeatedly of the high speed at which he operates. If he won't learn any other way, he must be disciplined. If he does it once more—fire him." On October 28 of the next year, Carroll was again written up for careless operation of the plane. This time the managers questioned his after-hours activities. (Courtesy of the Cincinnati Transit Historical Association.)

Iron steps lead to the pilothouse in the upper station at Mount Adams. The engineers had dominion over the powerhouse. Although they worked up to 12 hours each day, they took their jobs very seriously. One evening, the engineer noticed that one of the sheave wheels was unbalanced. An investigation revealed that the bottom bearing was completely worn away. The superintendent, realizing that the bearing at the abandoned Bellevue Incline was identical to the one at Mount Adams, sent the crew to fetch it. The sheave was blocked up with timbers and car jacks, no doubt from their own automobiles, and was replaced and in running condition by the next morning. (Above, courtesy of Bill Van Doreen; left, courtesy of Earl Clark.)

Although the mighty winding drums lasted the entire life of the Mount Adams Incline, 70 years, the teeth occasionally became worn and needed to be replaced. Many of the repairs to the machinery had to be made while the plane was in operation. Like members of a pit crew, the men on the inclines worked as a team. (Above, courtesy of Bill Van Doreen; right, courtesy of Earl Clark.)

Every day, each employee was responsible for answering a list of questions about his section of the incline, including the joints, bents, rails, and cables. The oilers had dominion over the track and trestle. A 24-inch-wide "chicken plank" was the oilers' catwalk, allowing them to walk down the center of the tracks as they inspected it. They also did repairs at the top and bottom stations. Whenever the 24-foot ties on the trestle needed to be repaired or replaced, it was done at night by lantern light when the plane was shut down. (Above, courtesy of Bill Van Doreen; left, courtesy of Phil Lind.)

The job of an oiler was physically demanding. Every morning, he crawled under the lift at the top station and rode it to the bottom to loosen the cable adjusters. These screws controlled the slack in the cable, which contracted overnight. In the afternoon, he climbed back under the truck and took up the slack as the cable stretched during the heat of the day. If this was not done properly, landings were rough, and passengers complained. (Courtesy of Bill Van Doreen.)

The men who walked up and down the tracks each day became comfortable with it, and accidents happened. In November 1922, Barney Ford was oiling cables on the sheave wheels and caught his foot. The wheel ripped the heel off of his shoe and burst two blood vessels in his leg. He spent two days in Deaconess Hospital and was off work for a month. Time off from work, whether paid or unpaid, was rare unless a worker was injured. The oilers worked 10 hours per day, 365 days a year. (Courtesy of Bill Van Doreen.)

Although there were never any passenger deaths on the Mount Adams Incline, three workmen were killed on the plane. James Covalt, a 62-year-old handyman, was working about halfway up the plane one day in September 1883. As the ascending approached him, he took a chance and simply laid down in the catwalk. There was only four inches of clearance, though, and he was dragged up the plane until the power could be shut down. His head was severed from his mangled body and the horrified passengers looked on as his remains were wrapped in a sheet and carried up the tracks. Then on July 15, 1919, carpenter Olie DeHart was struck by the truck coming up over Oregon Street and killed instantly. Another employee, Leonard Hilbert, was killed at the end of the Sixth Street Viaduct on April 15, 1929. The circumstances around his death are unknown. (Above, courtesy of Phil Lind; below, courtesy of Bill Van Doreen.)

Once the streetcar was properly positioned on the platform, the gateman took tickets from passengers in the waiting room and shepherded them onto the lift. Then he signaled to the operator that the car was on the lift, and the gate was closed by ringing two bells, which the operator acknowledged with two bells of his own. Once the final bell rang, the gate could not be opened for any reason. Any delay was noted, and the men were disciplined if the schedule was not met. At the same time, the workers lived with unrelenting pressure to meet the schedule and were often pushed to perform like machines. An injured worker frequently took the blame for an accident, whether it was his fault or not. (Courtesy of Phil Lind.)

May 2, 1932.

To Mr. Ostendorf

From Mr. Stewart

At 4:10 P.M. Saturday, April 30th, the operator of car #2439 outbound on the Mt. Adams Inclined Plane was down on the truck platform smoking a cigarette while the car was being trucked.

The above for your information, investigation and whatever action you may deem it advisable to take, letting me have report.

If the field of public relations existed during the heyday of the inclines, the owners would almost certainly have taken advantage of it. Letters like this from the files of the Mount Adams Incline were numerous. The owners were naturally concerned with the public's perception of their incline, and rightfully so. Passenger safety was of the utmost importance, so much so that every day the superintendent worked the controls himself for at least two hours. Hard landings caused passengers to become alarmed, something the management and owners did not want. Likewise, a motorman smoking a cigarette on the platform in front of passengers was an embarrassment to the owners. However, the employees worked hard and had a lot of responsibility, with few benefits. On May 31, 1921, they called a strike, and the engineers and operators were ordered to shut down the plane. An agreement was quickly reached, and the strike ended June 10. (Courtesy of the Cincinnati Transit Historical Association.)

Four

UPS AND DOWNS

Although the accident on the Mount Auburn Incline was the only wreck in the 70-year history of inclines where passengers were killed, the city never forgot. Because of its size and prominent location, the Mount Adams Incline was visible almost everywhere in the city. The incline was an unconventional method of transportation; it was only a matter of time, some thought, before it killed someone. The slightest accident, the owners felt, could threaten its existence. Accident reports were filled out at every incident, no matter how small. The reports provided detailed information about what went wrong and who was accountable, so the owners would know how to best defend themselves should anything as tragic as the Mount Auburn wreck happen. The name, badge number, and signature of both the motorman and the conductor were also required. (Photograph by Ed Kuhr Sr., courtesy of Dan Finfrock.)

While the employees of the inclines were often chastised for their mistakes, sometimes the management were the ones being reprimanded. On July 9, 1934, the smoke inspector cited the Mount Adams Incline for the dense smoke that was emitted from the smokestack for 12 and a half minutes during an hour. The very next day, it was given another citation for violating the smoke ordinance, this time for 14 and a half minutes. The letter explained that if the cause of the unacceptable smoke was due to problems with their furnace, then it needed to be remedied. The citation went on to say that if the problem was careless operation by the crew, then the management was "expected to admonish them." Harley Swift, the assistant general manager, apologized and explained that they had received a supply of "poor coal," and their inexperienced fireman did not know how to keep the smoke down. This was not the end of it, though. On August 3 they were cited again. (Courtesy of the Cincinnati Transit Historical Association.)

Engineers and Firemen Mr Adams Mr [?]

You are all aware of the smoke Complaints we have had for the last month. We must use every effort to remedy this Evil. Careful Inspection shows that it is no fault of our Equipment and I feel satisfied that we are not Cleaning our flues properly

Beginning at once — I want the flues Blowed every other night and also I want the Blower in each tube 20 Seconds. Engineers on duty will see to it that this order will be Carried out — and will be held Strictly Accountable. Also make report Each time on your daily Report. that flues was Blowed

When the fourth citation appeared less than two weeks later, Swift began to take it personally and suspected that there was some sort of animosity or prejudice behind the complaints. They had cleaned the boiler, used a solution to keep smoke down, and "cautioned and instructed our firemen, etc." He added that the boiler inspectors had never mentioned anything that appeared to be out of order. "This matter has disturbed me not a little," he wrote in a letter to the smoke inspector. In this letter to the engineers and firemen, Swift's frustration is evident, as he wrote that he was making "every effort to remedy this Evil." (Courtesy of Phil Lind.)

STOP THE LOSS

Brownell Engineers will show You How

Fuel economies are made possible with modern firing methods and equipment.

Uniform steam pressures or uniform temperatures are maintained.

The smoke nuisance is abated.

Plant output can be increased.

Labor conditions are improved.

Coal, efficiently fired, is the most economical of all fuels.

Modern coal burning equipment can be reasonably purchased and installed.

You should receive the benefit of a free survey and report by a trained Brownell representative. Call or write the home office or the dealer whose name is given on last page.

HUNDREDS OF DOLLARS GO UP THE CHIMNEY IN SMOKE
GREEN COAL SMOTHERS FIRE
INCANDESCENT COAL
COAL PARTIALLY BURNED IN ASHES
OPENING THE DOOR RETARDS FIRE
MONEY WASTED IN ASHES

Do you realize the losses you are bearing by continuing obsolete hand firing?

THE BROWNELL COMPANY — the World Over SINCE 1855 — DAYTON, OHIO, U.S.A.

The chief smoke inspector, Gordon Rowe, answered that Harley Swift was "greatly in error" in his assumptions that he was attacking Swift for personal reasons. It was not the job of the inspectors, he said, "to target one business over another." The matter was finally resolved when, at Rowe's suggestion, an automatic underfed stoker was installed. "Hand fired furnaces" said Rowe, "are long since obsolete." (Courtesy of the Cincinnati Transit Historical Association.)

> August 14, 1940.
>
> To F. Carroll, Operator
> J. Fehrmann Operator
> W. Kennard Operator
> H. Moffitt Relief Operator
> V. Alexander Relief Operator
> From F. Himes Gen. Foreman Bldgs. and Incline.
>
> Because of certain structural defects on the trucks, of which you are all familiar, it will be necessary for each of you while operating and the trucks are in motion to use the utmost care to prevent bumps at the landings, sudden stops or sudden changes in the rate of speed at which the trucks are moving.
>
> This order must be followed in strictest manner.
>
> *F. Himes*
> Gen Foreman Bldg and Incline.
>
> (Signed) *F. Carroll* Operator
> (Signed) *John Fehrmann* Operator
> (Signed) *Wm Kennard* Operator
> (Signed) *H M Moffitt* Relief Operator
> (Signed) *V. Alexander* Relief Operator

An August 1940, inspection revealed that the Mount Adams plane was unsound. Gusset plates on the piers were cracked and the 44-year-old trestle needed to be rebuilt. Fares from passengers had declined, however, and the owners hoped the plane would survive with a little pampering. The management had the operators sign a statement that they would avoid any "bumps," "sudden stops," or "sudden changes in the rate of speed." "This order must," the letter read, "be followed in strictest manner." Although it was only a matter of time before the entire thing collapsed, the constant pressure to make the schedule did not decrease. (Courtesy of the Cincinnati Transit Historical Association.)

No amount of careful handling by the operators could have straightened this pier on the south side of Baum Street. Although the piers were leaning downhill, the tension in the moving cables had a shearing effect on the trestle, pulling it in the other direction. The inspection determined that the plane lacked sufficient strength against this force. In other words, the entire plane, the piers, the wooden bents of the trestle, and all was being dragged uphill. (Courtesy of Earl Clark.)

QUICKER CHEAPER

The Price Hill Inclined Plane Railroad Company.

SAVE
TIME - GAS - TIRES - OIL

Effective May 1, 1920, the following rates of fare will be in effect. Some fares have been reduced while others are slightly increased. We hope our patrons will appreciate that, while cost of operation has steadily gone up, our freight fares have not been revised for years.

FREIGHT PLANE FARES.
Passenger Vehicles.

One horse vehicle, not over two persons	$.20
Two horse vehicle, not over four persons	.30
Runabout, not over two persons	.20
Five passenger auto, not over five persons	.25
Seven passenger auto, not over seven persons	.30
Motorcycle, not over two persons	.20

Freight Vehicles

	Light Load	Heavy Load
One horse wagon and driver	$.20	$.25
Two horse wagon and driver	.30	.45
Three horse wagon and driver	.50	.60
Four horse wagon and driver	.70	.80
One ton truck and chauffeur	.25	.35
Two ton truck and chauffeur	.40	.45
Three ton truck and chauffeur	.50	.55
Four ton truck and chauffeur	.60	.65
Five ton truck and chauffeur	.70	.75
Six ton truck and chauffeur	.80	.85
Seven ton truck and chauffeur	.90	.95

Two wheeled tractor or trailer, extra fare, 20c.
Four wheeled tractor or trailer, extra fare according to tonnage.
When length of vehicle requires whole truck, an extra charge of 10c will be made if fare is less than 50c.
Round trip, all vehicles, 10c more than one way.
All persons on vehicles, except driver or chauffeur, regular passenger fare.
Freight tickets good for $2.75 worth of rides are sold for $2.50.

To truck owners:
 It is much cheaper and quicker to use the Inclined Plane than to pull the long grade to Price Hill. We lift you up in one and one half minutes, a saving of over thirty minutes, besides gas, oil and wear on tires. Good level streets from top of Inclined Plane to all parts of Price Hill.

The owners of the Price Hill Incline tried to stay afloat for a number of years. This notice of a change in fare from 1920 shows that some fares went up, while others went down, and they tried to stay competitive. The inclines suffered a loss of ridership due to alternate routes that were more convenient. A note from the business records of the Price Hill Incline in 1911 says, "The passenger business has fallen this year owing to the fact that both Warsaw and Elberon streetcar lines are running in good shape." In 1929, the freight plane was shut down. (Courtesy of the Cincinnati Transit Historical Association.)

George B. Kerper

George Kerper was responsible for much of the suburban development in Cincinnati. Kerper was not satisfied with "stub lines" that radiated outward from downtown but did not connect. He wanted an integrated system and was eager to work with the men who ran the other streetcar lines. At the time, investment in the transportation business was considered risky. Because of this, the system was poorly funded. There was much competition and little cooperation. The routes were cloistered and confined to certain areas, which made things inconvenient for the passengers. Kerper, a Renaissance man, tried to revamp the system. He pushed to extend track lines and connect existing routes. He attempted to get trackage rights to use lines in the basin owned by the Cincinnati Consolidated Street Railway Company. However, he did not succeed.

In 1885, Kerper collaborated with some progressive thinkers to build the first cable car line in Cincinnati, which ran from downtown along Gilbert Avenue to Corryville. The four-mile line that ran from Fountain Square to Woodburn Avenue began operating on October 8, 1886. This illustration shows the Walnut Hills cable car sharing Gilbert Avenue with horse-drawn carriages around 1880. The cable house, once a fine Italian restaurant, still stands but is now abandoned. Eventually cable car lines were installed along Sycamore Street and Vine Street Hill. The frequent changes in temperature and humidity in Cincinnati caused the cables to expand and contract. Accidents were frequent. Sharp turns in the line caused people to be thrown from their seats or even from the cars. Although the experiment did not last, Kerper was successful in bringing public transportation to Walnut Hills. The photograph below shows track work at Peebles Corner in 1946. (Courtesy of Phil Lind.)

The hilltops were now easily accessed by the streetcars. Areas beyond the first suburbs of Mount Adams, Mount Auburn, Clifton, and Price Hill were discovered, and the communities of Walnut Hills, Mount Lookout, Hyde Park, Avondale, Glendale, and Delhi developed into bona fide communities. This photograph, taken during the 1937 flood, shows the Winton Shops where the streetcars were stored and repaired. Each district had its own carbarn. For example, the Route 49 cars were kept in the Avondale barn, the Price Hill cars were stored at the Depot Street carbarn, and so on. (Courtesy of Phil Lind.)

BODY = 7200#
TRUCK = 10370#
TOTAL = 17570#

GENERAL DIMENSIONS	
LENGTH OVER ALL	30'-4"
LENGTH OVER BODY	23'-0"
LENGTH of FRONT PLATFORM	3'-3"
LENGTH of REAR PLATFORM	3'-3"
WIDTH OVER ALL	7'-9"
WIDTH OF CAR AT SIDE SILLS	6'-8"
WIDTH OF SEATS	13 3/4"
WIDTH OF END SEATS	15"
HEIGHT RAIL TO SIDE SILL	28"
HEIGHT OVER TROLLEY BOARD	11'-8"
HEIGHT RAIL TO RUNNING BOARD	18"
HEIGHT RUNNING BOARD TO FLOOR	17"
DOOR OPENING	43 3/4"
POST CENTERS	30"
DISTANCE BETWEEN SEATS	16 1/4"
WHEEL BASE	6'-6"
SIZE OF WHEELS	33"

GENERAL INFORMATION	
SEATING CAPACITY	45
TYPE OF TRUCK	McGUIRE
TYPE OF SEATS	SLAT
WINDOWS	DROP
VESTIBULE WINDOWS	3 STAT'Y & 1 SLIDING
TYPE OF CONTROL	K9
TYPE OF MOTORS	800
TYPE OF BRAKE	CIN. ST'D HAND
EMERGENCY BRAKE	18" WHEEL
SINGLE END CONTROL	
LIGHT CIRCUITS	3 CLUSTERS - 3 LIGHTS EACH
TYPE OF HEADLIGHT	DAYTON #1561

464 CARS

THE CINCINNATI TRACTION COMPANY
OPEN CAR
9 BENCH
AMERICAN CAR Co. BLDS

OCT 23-1917

Before air conditioning, the Cincinnati Street Railway helped passengers beat the heat with open-sided cars, which were similar in style to San Francisco's streetcars. For a cheap date, men would take their ladies out to ride these open-sided cars on hot summer nights. (Courtesy of Phil Lind.)

A maze of lines hangs over the track switches on Ida Street north of the Mount Adams Incline. Before electric switches, the motorman had to maneuver by throwing the switch with a switch iron. At the rear of the car, the conductor moved the poles from one line to the other. When the switches were electrified, the motormen sent signals to the switches and wires to activate them. Signs along the routes informed them of any actions necessary to navigate through the switches. The trolley pole, which gravitated to an upright position, was connected to the 600-volt overhead wire with a trolley shoe. Occasionally, when a careless motorman sent the track switch one way and the wires another, it caused a derailment, fouling up the entire line. A crane car had to come out and put them back on track. The Overhead Line Building on Elm Street was the base of operations for that department. (Courtesy of Phil Lind.)

Five

THE END OF AN ERA

Parked automobiles line Fourth Street, the heart of the shopping district. Buses soon replaced streetcars, as they required no rail investment. The owners of the inclines were faced with huge operating costs and had to replace old, worn out trestles, machinery, lifts, boilers, and so on. Many repairs could not be made while the planes were in operation. The planes often had to be shut down completely and the work done as quickly as possible since there was no income from fares during this time. (Photograph by Ed Kuhr Sr., courtesy of Dan Finfrock.)

By 1924, the slanted track and tall chimney of the Fairview Incline are gone from the view looking north on Mohawk Street. Many of the rock foundations are still embedded in the hillside above Fairview Park. (Courtesy of Phil Lind.)

The desolate head house of the Bellevue Incline stands quiet and still. (Courtesy of Phil Lind.)

When the Bellevue Incline closed, the bottom station was razed and the Overhead Line Building was constructed to the east of the landing. (Courtesy of Phil Lind.)

The head house was converted into a storage building for the Cincinnati Street Railway after it was abandoned in 1926. (Courtesy of Phil Lind.)

115

After the Bellevue Incline closed the route became the No. 55 Vine-Clifton. The streetcar now ran from Fountain Square to the intersection of McMillan and Clifton Avenues, then left on Ludlow Avenue and right on Telford Street to Bryant Avenue. From Bryant, it continued to Middleton and turned around using a modified Y. The steep cliff on the right leads to the hilltop where the Bellevue House once stood. (Courtesy of Bill Van Doreen.)

Receipts from fares were down since the Sunday closing laws had shut down the Price Hill House, a big moneymaker. Expensive repairs to the plane ate into the meager income from fares. The sliding hill had to be terraced. New ropes, passenger cars, a rebuilt boiler and freight plane, as well as two fires, consumed any profits that were left. On July 31, 1943, the rails bent, and a car jumped the track. The timbers were so rotten they would not hold a spike. However, when the Price Hill plane was ordered shut down by the city, the Cincinnati Street Railway Company replaced the route from Eighth Street and State Avenue to the top of the hill with a shuttle bus. (Courtesy of the Cincinnati Transit Historical Association.)

The crumbling stone piers of the abandoned Price Hill Incline stand like sentries behind the old gatehouse. The gaping black holes of the upper station stare out on the city in this 1950 view from Eighth Street. The head house, now gone, served as a painful reminder of the fact that the beloved incline had carried its last passengers to the hilltop. Many of the foundations of each of the inclines lurk in the woods, waiting to be discovered, with the exception of Mount Auburn. Any remains of that incline are buried beneath the steps leading from the top of Jackson Hill Park to Seitz Street, following the route taken by those that fell to their deaths that day in 1898. (Courtesy of Bill Van Doreen.)

Would-be heir to the business, George T. McDuffie, poses for a photo shoot on the abandoned incline his family ran. His grandfather, also named George T. McDuffie, was secretary and treasurer of the Price Hill Inclined Plane Company. Young McDuffie holds one of the worn-out sheaves, which he passed on to a friend. Below, McDuffie, who knew the incline his entire life, holds a "Spitting Prohibited" sign. (Courtesy of Bill Van Doreen.)

The lower station was hit by a gasoline truck months before it was to be razed. The building, and the passenger lift behind it, became a magnet for vandals. McDuffie had the misfortune of witnessing both the slow death and the desecration of the incline, his family's cherished memento and the fruit of his grandfather's sweat. (Courtesy of Bill Van Doreen.)

The Mount Adams Incline was in financial trouble. The lift, filled with cars rather than streetcars, was a sign of the changing times. Steady losses in passenger fares from alternate routes and increased automobile use combined with estimated costs of $150,000 for repairs and an annual operating loss of about $50,000, plunged the incline into financial ruin. (Courtesy of Phil Lind.)

A man and his automobile have the incline to themselves. The two shadows on the windshield of the car are reflections of the overhead trolley carriage. (Courtesy of Phil Lind.)

The Cincinnati Street Railway No. 1125, one of the newer streetcars, rides to the top. By this time, buses were being used for public transportation, but the steep grades of Cincinnati's slopes were difficult for buses to pull. Streetcars were used to climb the more extreme hills, such as Milton Street, Liberty Street, Vine Street, McMillan Avenue, and Warsaw Avenue. (Courtesy of Phil Lind.)

The Eden Park entrance bridge carried streetcars and pedestrians since 1878, nearly 70 years. By the 1940s, the bridge was said to be in such bad condition that pieces of it were allegedly falling off and injuring those who passed under it. Since both the park board and the Cincinnati Street Railway had shared in construction of the bridge, the issue of liability was unclear, and the Cincinnati Street Railway discontinued use of the iron superstructure in July 1947. Streetcars now ran straight up Gilbert Avenue from the city. Studies of both restoring the bridge and demolishing it were considered. A city official spoke against repairing the bridge, saying that it would be "like patching an old pair of pants," and the old bridge was demolished. Ida Street was redirected, curling around the eastern side of the art museum and connecting with Eden Park Drive near the reservoir. (Courtesy of Phil Lind.)

Eventually the need for fast, modern transportation from the very suburbs that were made accessible by the inclines led to the perception by some that the inclines were an inconvenient, outdated mode of transportation. Because of the prohibitive cost of operation, the street railway companies began to see them as a barrier to profits and wanted out of the incline business. When an inspection uncovered defects in the plane, the owners declared the incline "closed for repairs." This view from Fifth Street in the 1940s shows the Mount Adams Incline during the last decade of service. (Courtesy of Phil Lind.)

The upper station of the Mount Adams Incline stood long after it was abandoned when all hope of its resurrection was gone. The pilothouse, once the heart of the incline, is empty. A wooden barricade across the landing prevents the curious from wandering onto the steep tracks. The overhead framework for the trolley wires can be seen through the deserted head house. This photograph was taken on March 6, 1949. (Courtesy of Fred Bauer.)

A wooden barricade blocks the entrance to the upper landing of the abandoned Mount Adams Incline in this photograph, taken on March 6, 1949. In the lower photograph, the doorway to the entrance of the station waiting room is boarded up. The overhead beam that supported the gate structure remained, along with the tracks embedded in Lock Street, long after it was demolished. Today Interstate 71 runs through the area in the foreground. The station, the liquor store, Lock Street, and many of the houses on Baum Street were destroyed when the new highway was constructed. (Above, courtesy of Phil Lind; below, photograph by Malcolm McCarter, courtesy of Phil Lind.)

Cry of "Save the Incline" Echoes; Mt. Adams Fears Closing Permanent

The "Save the incline!" battle cry was heard on top of Mt. Adams again Wednesday.

And it was to be echoed in Council chamber. Councilman Edward N. Waldvogel declared that the famed Mt. Adams incline must be put back into operation quickly even if the city has to operate it.

City Manager... [text obscured] portation at all without the incline."

"They've put a gate at the top of the incline," she continued, "and people are saying we've lost our battle. But we aren't quitting. We hope to meet soon with Mayor Cash [and Counc]ilman Rich and try [to do so]mething out."

[Cincinnati Street] ailway, losing about [a y]ear on the incline, [wants] to close it permanently. Waldvogel said he [put i]t in Council that [the city] or the public utility [should] take a look at the [incline]. He added, however, [he was] not accusing the [Stree]t [Railway] of longer delay than is...

...an, on the other [sid]e is "definite"...

may lead to abandonment of the incline.

"At the end of a year they'll probably say the whole incline is rotten," she declared.

Councilman Urges Renewal Of Incline As "Lift For City"

Reopening the Mt. Adams Incline would give Cincinnati a needed lift, Councilman Edward N. Waldvogel told the Civic Club at the Hotel Gibson at noon yesterday.

"I cannot agree with Morris Edwards, President of the Cincinnati Street Railway Co., that everything done in Cincinnati must rate a... If such were the...

...ing delayed because there is place to house those persons w... homes are blocking the project declared. Waldvogel said the gram would move along ra... once the housing shortage wa... lieved.

He pointed out that the follow[ing] highway improvements woul[d] gin in 1949: Raising of Beech... ...at a cost of $2,444,200, ... the state ...ment; w... from Bee... d Avenue ...d widenir m Main S... e at a co... he Sixth S... ich work ember, wou... 1949.

[Ci]ty Offered Mt. Adams [In]cline in Sale or Lease

[Of]ficials Considering Street Railway Proposal.

The question of the future of the Mt. Adams Incline will mark [t]ime pending a[ction] by City Solici[tor]... ...of obsolete and uneconomical hoisting machinery, or an additional $75,000 to $90,000 for mo[d]ernization of the hoisting equi[pment].

The operating cost for 1947 $61,210.44. He estimated th[e] operating cost of $64,311. $69,970.95 should wages i... 10 per cent.

Edwards declared the [company] is faced with the question of... cing the operating co[st]... ...or by spending a... ...ment for ho... would st... t of ap... ear, he a...

Sentiment to Abandon Incline Reported Growing

With another meeting on the [quest]ion of Mt. Adams incline [schedule]d Nov. 8, officials of [the Cincinnati Street] Railway Co...

Use of Incline Decision Again Is Delayed

—Tuesday, November 9, 1948—

The decision as to whether the Cincinnati Street Railway Co. would put the Mt. Adams Incline back into operation was at least two weeks off Tuesday.

Officials of the utility concern told members of Council's Utilities and Highways Committees...

operation. Track repairs have averaged $30,000 a year for the last several years, he said. The annual operational deficit of the incline has been estimated at $45,000 a year.

Edwards promised to have for the next meeting, two weeks hence, figures showing the number of persons who ride the Mt. Adams bus, as compared to the number who rode the incline.

Mayor Albert D. Cash, utility chairman, repeated his belief that the city could compel the Street Railway Co. to repair the incline. Edwards said this would just ad[d] to the financial...

In total, 40 letters to the editor were written to the city's three newspapers, the *Cincinnati Enquirer*, the *Cincinnati Times Star*, and the *Cincinnati Post*, protesting the closing of the Mount Adams Incline. The *Times Star*, whose Broadway Street offices had a clear view of the incline, beseeched the city to restore the thing. One editorial stated, "The incline was really not 'needed' any more than the zoo or the parks are needed, but that a city that limits itself to the bare necessities is a city without character."

A cartoon in the March 5, 1950, *Enquirer* illustrates the public's frustration and outrage over the dilemma of the Mount Adams Incline. Of the five inclines, the Mount Adams and the Price Hill seemed to be missed the most. Price Hillians, many of who now had to walk more than a mile every day to catch a streetcar to work, begged the city to restore their beloved incline. Schoolchildren diligently swept the floor of the abandoned head house in hopes that one day the giant winding drums would begin turning once again. The Mount Adams plane, famous the world over since the time of the Highland House, was a trusted friend of the community, and the city reeled with bitter disappointment. (Courtesy of the Cincinnati Transit Historical Association.)

Right up until the end, passengers watched the city from the lifts of the Mount Adams Incline. According to a July 31, 1947, article in the *Enquirer*, the Mount Adams Incline was "the number one attraction in Cincinnati's guidebook." This photograph was taken on September 2, 1945. (Courtesy of Phil Lind.)

The constant battle between progress and preservation is obvious in this photograph taken in the late 1940s. The towering, modern skyscrapers point to the sky behind the destitute Mount Adams Incline. The last streetcar, No. 2446, was carried up the incline at 12:46 a.m. on July 25, 1947. (Courtesy of Earl Clark.)

www.arcadiapublishing.com

Discover books about the town where you grew up, the cities where your friends and families live, the town where your parents met, or even that retirement spot you've been dreaming about. Our Web site provides history lovers with exclusive deals, advanced notification about new titles, e-mail alerts of author events, and much more.

MADE IN THE USA

Arcadia Publishing, the leading local history publisher in the United States, is committed to making history accessible and meaningful through publishing books that celebrate and preserve the heritage of America's people and places. Consistent with our mission to preserve history on a local level, this book was printed in South Carolina on American-made paper and manufactured entirely in the United States.

This book carries the accredited Forest Stewardship Council (FSC) label and is printed on 100 percent FSC-certified paper. Products carrying the FSC label are independently certified to assure consumers that they come from forests that are managed to meet the social, economic, and ecological needs of present and future generations.

FSC
Mixed Sources
Product group from well-managed forests and other controlled sources

Cert no. SW-COC-001530
www.fsc.org
© 1996 Forest Stewardship Council

Find Your Place in History.